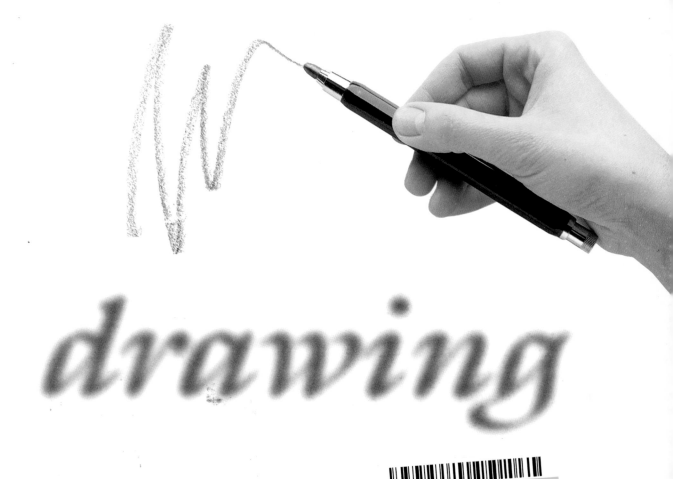

# drawing

English translation © Copyright 1998
by Barron's Educational Series, Inc.
Original title of the book in Spanish is *Para empezar a pintar Dibujo*
© Copyright Parramón Ediciones, S.A. 1997—World Rights
Published by Parramón Ediciones, S.A., Barcelona, Spain

Author: Parramón's Editorial Team
Illustrator: Parramón's Editorial Team

*All inquiries should be addressed to:*
Barron's Educational Series, Inc.
250 Wireless Boulevard
Hauppauge, New York 11788
http://www.barronseduc.com

Library of Congress Catalog Card No. 97-42798

International Standard Book No. 0-7641-0550-7

**Library of Congress Cataloging-in-Publication Data**
Para empezar a pintar dibujo. English.
    Learning to paint, drawing / [author, Parramón's
Editorial Team ; illustrator, Parramón's Editorial Team].
        p.   cm.—(Barron's art guides)
    ISBN 0-7641-0550-7
    1. Drawing—Technique.   I. Parramón Ediciones. Editorial
Team.   II. Title.   III. Series.
NC730.P2413   1998
741.2—dc21                                           97-42798
                                                        CIP

Printed in Spain
9 8 7 6 5 4 3 2

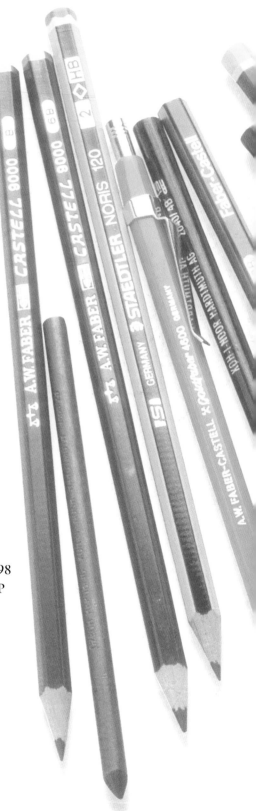

# BARRON'S ART GUIDES
# LEARNING TO
# PAINT
## drawing

# BARRON'S

# Contents

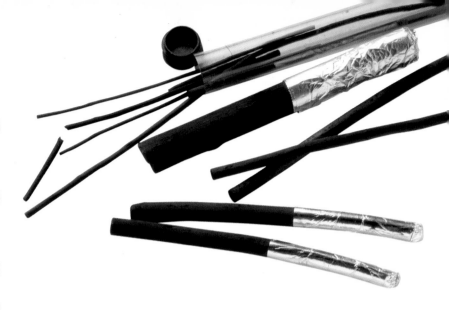

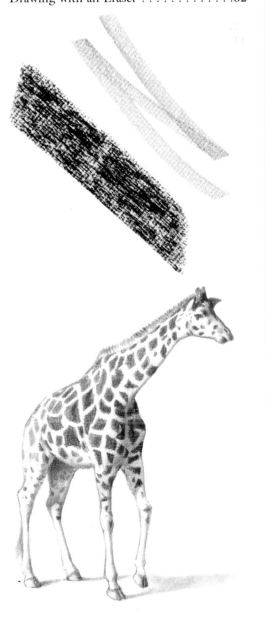

Drawing is the foundation for many art forms, such as charcoal, pastels, watercolors, oil, and acrylics. Drawing is also an art form in itself, and offers the same opportunities for  expressiveness as do other forms. It also uses the most simple materials, which makes it particularly appealing. When an artist embarks on a monochrome drawing, whether  in charcoal or graphite, he does not have to be concerned with color problems. Still, it is not easy to execute a successful drawing if you aren't familiar with the appropriate skills.

This book is designed to show the beginner how to draw in easy steps. Chapter by chapter, readers will gradually acquire essential knowledge—from the basic supplies needed to handy hints and secrets—to help them tackle those subjects they may wish to draw.

Aside from the useful techniques included in this volume, it is important to remember that only through practice and perseverance can the novice hope to handle the drawing pencil like a master.

# Graphite and Charcoal

Due to their versatility, blending capacity, and tonal range, charcoal and graphite are the kings of drawing.

## Graphite

The graphite or lead pencil is the most traditional drawing medium of all. The degree of hardness of the different leads available on the market depend on the amount of graphite, mineral oil, and clay they contain.

The mark produced by a graphite pencil is greasy, dark, and slightly shiny. Graphite adheres easily to paper, thus allowing it to be blended. The intensity of its tone can be changed according to the amount of pressure used to apply it to the paper. Graphite pencils can be sharpened easily. Finally, graphite can only be removed with an eraser. All these characteristics have contributed to making the pencil the most popular medium for making sketches and drawings.

There is a wide range of pencils to satisfy all tastes.

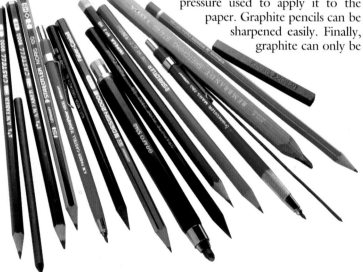

The hardness of graphite is indicated by a letter and number on the pencil.

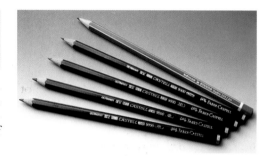

The most common form of graphite is the classic wooden pencil.

## Degrees of Hardness

There are various types of graphite—in other words, graphite comes in soft or hard versions. The greater the amount of graphite, the softer and darker the line produced by the pencil. Conversely, the lesser the amount of graphite, the lighter the line.

Graphite is also shaped in the form of a pencil, pointed at one end, or manufactured in quadrangular sticks.

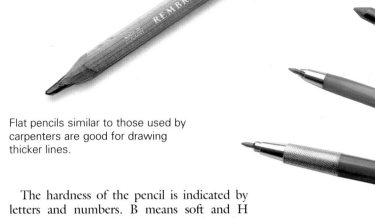

Flat pencils similar to those used by carpenters are good for drawing thicker lines.

The hardness of the pencil is indicated by letters and numbers. B means soft and H means hard. The higher the number that accompanies the letter, the softer or harder the graphite. The HB classification indicates pencils of a medium hardness.

There are mechanical pencils designed for every thickness.

## Charcoal

Charcoal is nothing more than a piece of completely carbonized wood with which one can draw. Once this material has been applied to paper, it becomes powdery. For this reason, drawings executed with this medium are delicate and require fixative to be applied once the work is completed.

Nowadays, charcoal is sold in two forms: compressed and natural. Compressed, or manufactured, charcoal comes in a smaller range of hardness and is sold in the form of sticks and pencils. These can be purchased in various thicknesses for drawing many kinds of lines.

Charcoal is applied directly onto paper and can be blended with ease but, unlike graphite, it only has a single intensity of tone: pure black.

Compressed charcoal is sold in a limited range of hardness.

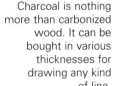

Charcoal is nothing more than carbonized wood. It can be bought in various thicknesses for drawing any kind of line.

## What You Can Buy

*Graphite.* Can be purchased in pencil form, thick with a pointed end similar to a pencil's (for large-scale work formats), and in various sizes for use with a mechanical pencil.

*Charcoal.* Generally sold in sticks, whether it is natural or manufactured. It is also available in a wooden pencil format.

## Charcoal or Graphite?

You may sometimes have doubts about which medium to use. It is difficult to give advice on this point, because the material you choose depends on what you want to do. The choice, then, is mainly a personal matter. It is important to bear in mind that charcoal is a messy medium, more suitable for expressive works than detailed drawings, for which there is nothing better than pencil. Because both media are inexpensive, you can afford to practice with both in order to master the techniques and discover which suits your work better.

# The Paper

Paper is the most common material you will draw on. Although almost any type of paper can be used, there are special kinds designed exclusively for drawing.

## Drawing Paper

Drawing paper is sold in pads of varying sizes and kinds for use with charcoal, graphite, and other media.

Drawing paper can be purchased in loose sheets for drawing large-scale work or for cutting to the size required by the artist.

With the exception of paper with an extremely fine surface, to which graphite cannot adhere, any type of paper can be used for drawing. In fact, many artists use rough paper such as wrapping paper or sheets of recycled paper for drawing their sketches.

There is also paper manufactured especially for drawing. It is sold in specific textures and different degrees of smoothness suitable for each kind of drawing, and for use with different media like graphite, charcoal, or pastels.

## What You Can Buy

Most drawing paper is sold in pads held together with either glue or metal coils. The price of this type of pad varies according to the quality of the paper and the amount of pages it has. Drawing paper also comes in individual sheets of different sizes that the artist can cut to any shape or size.

Art supply stores offer nice metal coil sketch pads for your work.

# Types of Texture

When discussing the texture of paper, the artist refers to its roughness. Different styles of drawing and different media require different types of paper. Detailed drawings made with hard graphite need a glossy or fine-textured paper. Medium-textured paper is good for any style of drawing, although it is not particularly good for small details. Thick-textured paper is best for use in charcoal or graphite works of a more expressive or impressionist nature, because its roughness does not allow any sharp or defined lines.

# Types of Paper

Some paper is made especially for graphite, some for charcoal, and some for drawing in any medium. The artist can also draw on economical types of paper, such as recycled, which give a special quality to the picture. In this case, graphite is the most suitable medium, because it sticks to almost any surface. Charcoal, on the other hand, needs a somewhat porous surface in order to retain the pigment.

On fine-textured paper, the edges of a charcoal line are perfectly sharp.

When charcoal is applied to rough paper, you can see that you get suggestive lines, rather than sharp, precise lines.

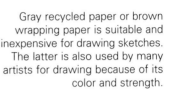

Gray recycled paper or brown wrapping paper is suitable and inexpensive for drawing sketches. The latter is also used by many artists for drawing because of its color and strength.

# Qualities and Recommendations

When you begin drawing, you should use inexpensive paper so you can work confidently without worrying about making mistakes. Later on, when you have mastered the technique a little, you can start using better-quality paper.

Colored paper is very popular for drawing because the color of the paper can be incorporated into the work. Colors can give a warmer character to works than pure white.

1. Ingres paper. This quality of paper is most commonly used for drawing with charcoal and pastel. It has a nice texture that holds the charcoal very well.

2. Basic paper. This is the most popular drawing paper. It is fine textured and mainly suitable for graphite, but can also be used with charcoal.

3. Graphite paper. This is particularly good for use with a graphite pencil. Its surface has an extremely fine texture that thoroughly absorbs the graphite, and lends itself to a variety of styles.

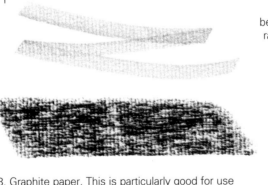

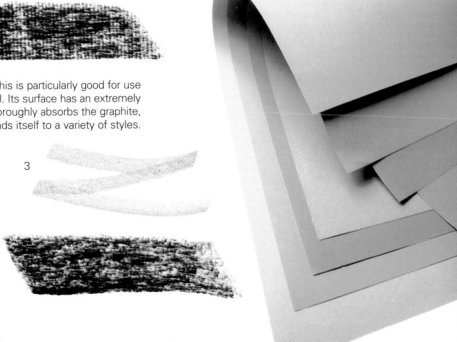

# Blending Sticks and Erasers

**Soft rubber erasers and soft plastic erasers for erasing graphite.** There are varying degrees of softness depending on the manufacturer.

In addition to pencil or charcoal and paper, there are other important materials used in drawing.

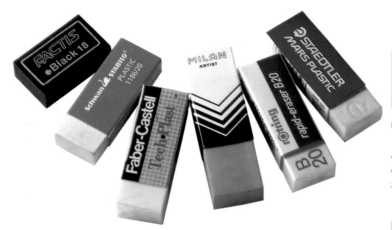

## Erasing

To erase graphite lines, you use soft erasers made of rubber or plastic. For charcoal, the best type of eraser is the kneaded eraser, or a simple rag. (See Erasing with an Eraser, pages 26–27.)

**Kneaded erasers for erasing charcoal.** They are normally square shaped, although with use they gradually look like a lump of putty.

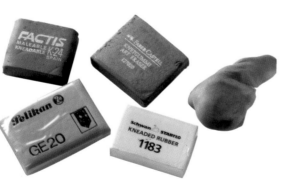

## Blending

Many artists use their fingers for blending pencil or charcoal, although to deal with smaller zones and create softer effects it is better to use a blending stick. (See Blending, pages 24–25.)

**Rags.** They can be used to clean hands or erase large areas of charcoal. The rag can also be used for blending.

**Cotton swabs.** They can be used as tiny blending sticks, although the result is less precise and soft.

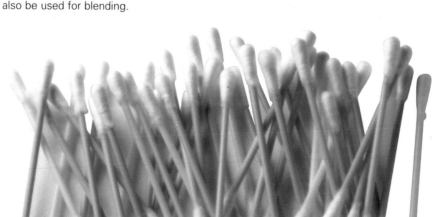

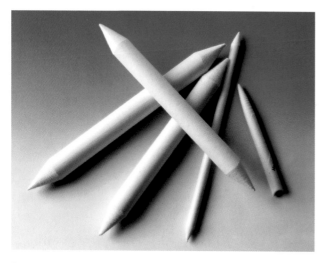

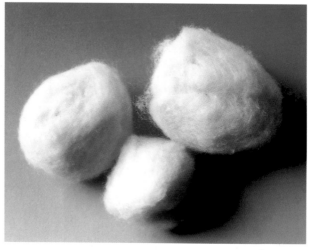

**Blending sticks.** These are used to blend graphite and charcoal lines, and are simply paper rolled into a point. They are sold in various sizes for blending both large and small areas. Sometimes they are used to create special effects. (See Drawing with Charcoal, pages 54–57.)

**Cotton balls.** They are handy for blending large areas and creating background effects.

**Sharpener.** A strip of wood with several sheets of sandpaper attached on top can sharpen sticks of charcoal.

# Pencil Sharpeners

The points of pencils, graphite sticks, and charcoal sticks wear down with use, so it is necessary to sharpen them. There are many kinds of sharpeners to choose from. (See Using Graphite, pages 18–19; and Using Charcoal, pages 20–21.)

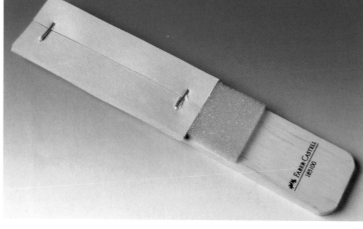

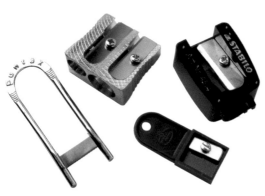

**Pencil sharpeners.** There are many kinds and sizes to choose from and are used to sharpen all kinds of pencils, as well as fine graphite used in mechanical pencils.

# Fixative

Graphite adheres well to paper. Charcoal, on the other hand, deteriorates quickly when exposed to air, so it is important to apply a fixative to protect your finished drawing.

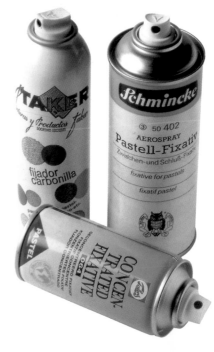

**Utility knife.** In addition to cutting paper, the utility knife can also sharpen graphite leads.

# Boards and Easels

The drawing board is a basic item for the artist, because it is essential to have a surface that supports the paper.

## Drawing Boards

Although many sketch pads include a sheet of cardboard that serves as a support, most artists place their paper on a wooden board. Drawing boards must be light, but strong enough so you can either place one on an easel or hold it with one hand while supporting it on your knees or the edge of a table.

Drawing boards can be made of virtually any type of wood, as long as it is light and practical. Two types that are particularly useful are particle board and plywood, especially if you are working with hard graphite or need to apply a lot of pressure. Because the board has a smooth surface, the paper will not be damaged. It is important to bear in mind that a board with a rough surface will inevitably affect the appearance of the drawing.

## The Size of the Board

A drawing board should be about 2 inches (5 cm) larger than the paper you are going to attach to it. In other words, if you draw on standard format paper of 9 × 12 in (24 × 32 cm) the drawing board should measure approximately 11½ × 14 in (30 × 37 cm).

Drawing boards are not sold in art supply stores, so you might have to ask a carpenter to make one for you. They are cheap and long lasting; it is useful to have several different shapes and sizes.

Paper can be attached to a plywood board with drawing pins, although they will leave tiny holes on the surface.

Drawing boards can be made of any type of wood or other material as long as they are light and sturdy.

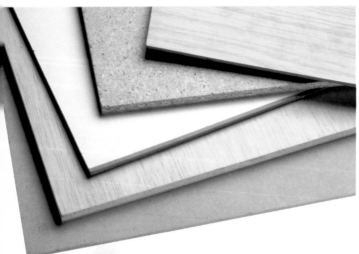

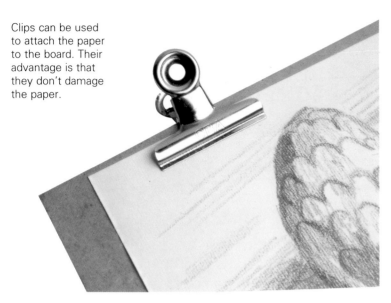

Clips can be used to attach the paper to the board. Their advantage is that they don't damage the paper.

Artist's masking tape is ideal for fastening paper to plastic-coated boards and hard surfaces like plywood. This method allows the paper to be stuck down on all four sides, which permits the painter to blend and erase without creasing the paper.

# Supporting the Board

The drawing board is the surface on which you put paper to draw. In reality, if you are not going to draw large pictures, $3 \times 2.5$ ft ($100 \times 70$ cm) for example, there is no need to use an easel, because you can rest the board on the edge of a table, on your knees, or on a pile of books placed on a table to get a slant.

It is important to draw on a slanted board to avoid errors of perspective.

# Easels

An easel is the support on which a drawing board can be placed. The common easel is normally used for large-scale drawings. Smaller ones can be done on table easels or special drawing boards.

Any easel can be used for drawing, although it is preferable to use one that can be slightly tilted. There are easels made especially for drawing that include two boards to which paper can be attached.

The drawing easel has a drawing board made of chipboard incorporated into its design.

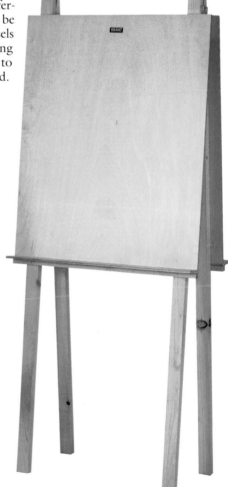

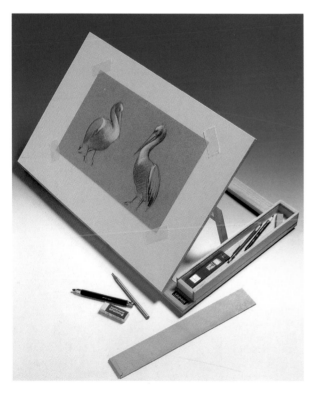

The table drawing board contains a handy pencil holder. It is light and can be tilted however the artist wants.

# Pencil Boxes and Folders

The materials required for drawing should be light and simple. Pencils, erasers, sticks of charcoal, and other accessories can be stored in a box, and the paper should be kept in a folder or portfolio.

A pencil set with assorted pencils includes a range of thickness and hardness for drawing on any scale. Also included are a soft eraser and a kneaded one, a pencil sharpener, a charcoal sharpener, and a blending stick.

## Boxes and Pencil Sets

Pencils and charcoal can be purchased in art supply stores in individual units. By buying items individually, the artist can personalize his or her drawing equipment. But there are also pencil box sets that contain everything an artist will need.

Some provide a range of pencils or sticks of charcoal with varying degrees of hardness to enable the artist to draw any kind of picture, whereas other sets contain

These two boxes combine two small pencil sets for drawing in graphite, charcoal, chalk, and crayon. One includes a kneaded eraser, and the larger set has a blending stick.

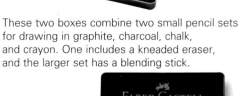

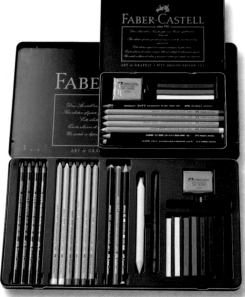

A metal box containing 12 graphite pencils with an entire range of hardness from the soft 8B to the relatively hard 2H. This is a light and easy-to-carry set.

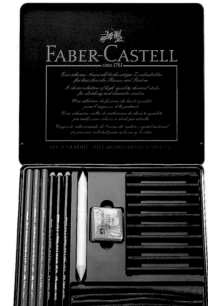

A set for drawing in charcoal made up of sticks of natural charcoal, in addition to sticks of compressed charcoal and wooden pencils, both of varying degrees of hardness. It also contains a blending stick and a kneaded eraser.

specific materials for drawing in charcoal. There are also sets available that have both media, as well as crayons and white chalk for touching up or adding color.

This metal pencil box is ideal for carrying the artist's drawing materials, because it takes up very little space. In as small a space as this, it is possible to store many pencils with varying degrees of hardness, sticks of charcoal, a blending stick, two erasers, and even a rag for cleaning one's hands or erasing charcoal.

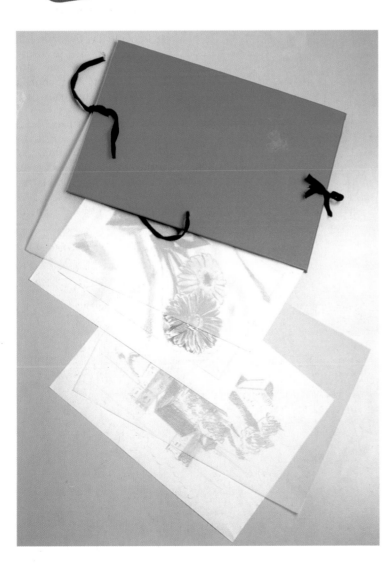

# Personal Pencil Sets

Aside from the practical pencil set combinations sold by manufacturers, there is also the personalized pencil set preferred by some artists. It may be simply a wooden box that the artist uses to carry the pencils, charcoal sticks, erasers, and blending sticks that one most frequently uses.

# Folders

Folders are also essential for storing finished drawings. Any type of folder will do, although the best are the classic drawing portfolios that can be tied with cords in order to keep the sheets perfectly flat.

It is useful to place sheets of tracing paper between the drawings in the folder in order to prevent them from rubbing together and getting damaged.

The folder stand is a practical piece of furniture for prolific artists. Folders containing drawings can be stacked horizontally so the artist can see the contents of the folders without having to take them out.

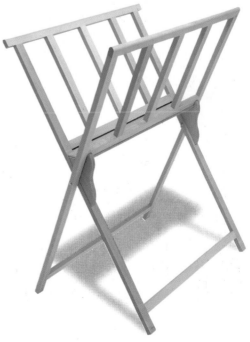

# Other Accessories

In addition to pencils and paper, artists usually need other items to make their work easier.

**Masking tape.**
Ideal for preventing paper from creasing when you are erasing or working wet, because the paper is firmly held down on all sides.

**Drawing pins.**
Drawing pins are excellent for keeping the paper firmly attached to the board; their one drawback is that they leave holes in the paper.

**Paper clips.**
Clips are ideal for keeping the paper firmly attached. Because they are easy to remove, they are especially good when the artist is drawing quick sketches and has to change the paper frequently.

## Attaching the Paper

The basic media used to draw on is paper. Because it is flimsy, the artist will have to fasten it to the drawing board when not using a sketch pad. There are many ways of doing this depending on the needs of the artist.

## Drawing Straight Lines

The ruler and triangle are essential for making linear drawings. These items are also useful for getting the correct perspective in a freehand drawing, and for measuring paper before cutting it.

**Triangles.** The right triangle and 30/60 triangle can be used in the same way as a ruler, and can also help the artist find specific angles.

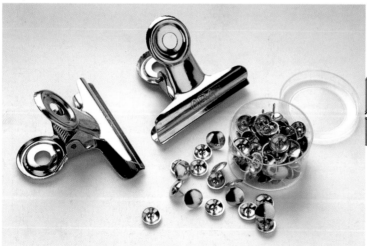

**Ruler.** A ruler is useful for drawing straight lines accurately, such as those in a sidewalk, or when drawing something in perspective, such as vanishing horizon lines. A ruler is also useful for measuring paper size. (See Perspective, pages 34–35.)

## Cutting

Artists do not always work on the same scale; eventually they have to cut paper to smaller sizes. This can be done with a utility knife or scissors. Large sheets should be cut to size using a utility knife and a ruler. Scissors are all right for smaller formats.

**Utility knife.** This is used for cutting paper with the aid of a ruler, and also for sharpening pencils and graphite.

**Scissors.** These come in handy for cutting paper and masking tape.

## Other Materials

A cardboard frame and white chalk aren't indispensable, but they do come in handy. Because they are inexpensive, there is no reason not to have them.

**White chalk.** Whether it is in the form of a pencil or stick, chalk comes in handy for adding highlights and for restoring white sections of the paper (See Tones, Light, and Shadows, pages 46–49).

**Frame.** The cardboard frame is used to envision the composition, either for subjects in nature or in a photograph. (See Framing, pages 30–31.)

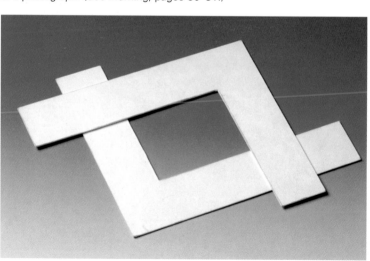

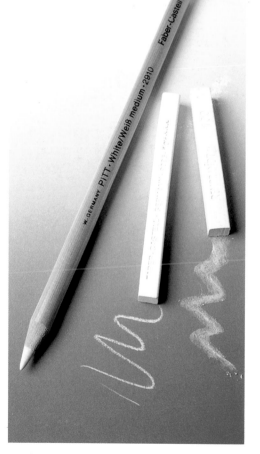

# Using Graphite

Graphite, sometimes known as lead, is the mineral with which pencils and graphite sticks are made. There are different degrees of hardness, depending on the composition of the pencil. Also, different tones can be obtained from a single pencil according to the pressure with which you apply it to the paper.

## How to Hold a Pencil

For drawing details and short lines, graphite, pencils, and mechanical pencils must be held the way one would when writing. This will provide the correct angle for the utensil to hit the paper. The pencil must be sharpened often to draw fine lines.

Wooden pencils and mechanical pencils are normally held the way one would when writing. This position allows the artist to draw small areas and details. To get a freer type of stroke, it is better to support the body of the pencil within the palm of your hand so you can guide it in any direction with a simple movement of the wrist.

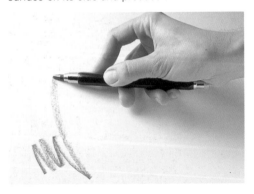

Freehand pencil work, such as curves and long lines, can be achieved by holding the body of the pencil within the palm of the hand. This technique allows the pencil to move across the surface on its side and produce thick strokes.

## Fine and Thick Lines

In order to draw fine lines with graphite, the pencil must be sharpened properly. The best way to get this kind of stroke is to hold the pencil in an almost vertical position and let it move freely across the surface of the paper. Thick lines, on the other hand, are produced by holding the pencil at a slanted angle. This way more of the graphite will come into contact with the paper and produce thicker lines.

Thick and fine strokes are made by applying the pencil to the paper at different angles.

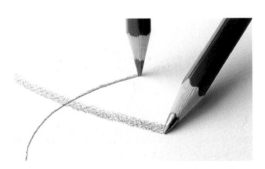

Graphite with a pencil-like body can achieve these kinds of effects, according to the angle of the graphite on the paper.

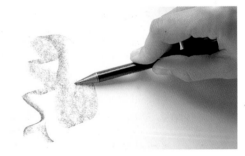

Graphite sticks have sharpened corners that can be used to draw fine lines, whereas its sides leave thicker marks. They are held like pieces of chalk between the index finger and the thumb.

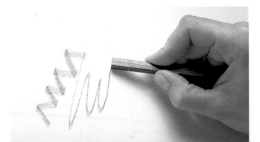

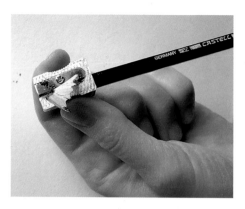

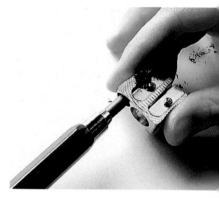

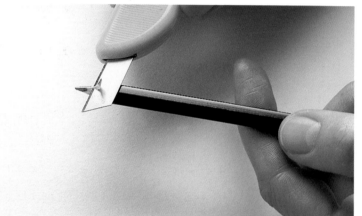

A pencil sharpener can be used to sharpen both pencils and graphite sticks.

## Sharpening Graphite

Graphite in pencil or stick form is sharpened using a pencil sharpener. Some artists prefer to sharpen their pencils with a utility knife, because you can create edges and vary your result. Another advantage of the utility knife is that it allows you to remove more of the wood protecting the graphite; this way the graphite is longer and does not require sharpening as often.

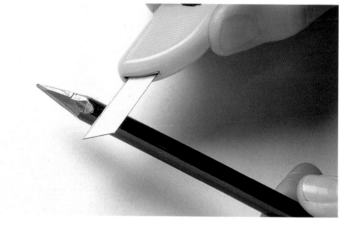

By sharpening graphite with a utility knife, the artist can create edges or corners that can be used to create details.

## Drawing Cleanly

Once your drawing has reached an advanced stage, you have to take care not to rest your hand on the paper while drawing, because you will remove part of the graphite and leave smudge marks. When you are drawing details, and it is essential to steady your wrist, the best thing to do is place a clean piece of paper between your arm and the drawing to prevent it from getting dirty.

**REMEMBER...**

■ The thickness of the line depends on how much the graphite has been sharpened, as well as the angle with which it is held against the paper.

■ Pencils and graphite can be sharpened with either a pencil sharpener or a utility knife.

# Using Charcoal

Charcoal is of plant origin and is lighter than graphite. It can be used to draw fine, medium, and thick lines. Charcoal is a soft material that crumbles easily, which makes it easier to blend, but also dirtier.

Charcoal is held in the hand like a small stick.

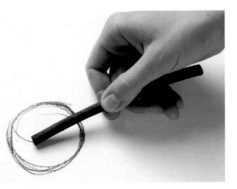

## Drawing with Charcoal

A stick of charcoal is held between the fingers with the main part resting in the palm of the hand. Because of its brittleness, charcoal should never be held like a pencil. It also crumbles and smears, so you should never rest your hand on the paper when drawing.

To draw fine lines, the artist should take advantage of the corners that form at the tip of the stick as it rapidly wears down.

**REMEMBER...**

■ Charcoal is extremely fragile and breaks easily.

■ Charcoal does not leave a uniform mark on paper and rubs off at the slightest touch.

■ Don't touch the paper when your hands are dirty, or you will leave charcoal fingerprints on it.

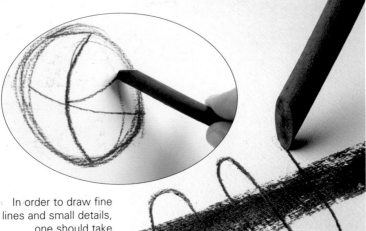

In order to draw fine lines and small details, one should take advantage of the corners of a new stick, or those that appear after use.

When you want to fill in a large area or make thick lines, it is best to hold the stick flat.

With use, charcoal sticks wear down and produce flat sides on the tip that are good for drawing lines of medium thickness.

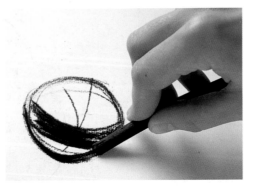

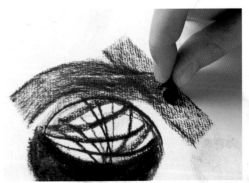

If you want to draw lines of medium thickness, it is best to hold the stick flat and draw with its entire side.

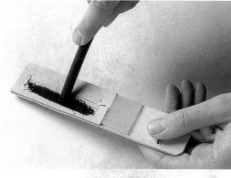

The easiest way to sharpen a stick of charcoal is to rub it on a piece of rough paper, or, better still, use a charcoal sharpener, which is essentially a piece of sandpaper attached to a strip of wood.

## Sharpening Charcoal

Despite the fact that corners or tips are produced when drawing with charcoal, it may still be necessary to sharpen them in order to add detail. This can be done by using a piece of sandpaper, or by rubbing the stick against some rough paper.

Regarding pencils, it is necessary to use either a pencil sharpener or a utility knife to remove the wood that protects the graphite.

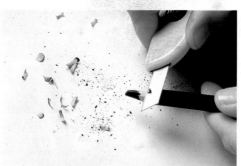

## Charcoal Smudges

Charcoal does not adhere well to paper, crumbles easily, and dirties your hands, so it is important to avoid smudges by not resting your hand on the paper. It is also important to take care not to dirty those parts of the drawing that you wish to keep white.

In order to prevent your charcoal drawings from getting damaged or deteriorating, it will be necessary to apply fixative to them once they are finished. If you don't, the charcoal of your drawing will disintegrate when it is stored away in a folder.

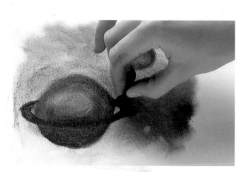

Charcoal smears easily, so artists should avoid resting their hands on the paper when drawing.

The slightest contact with charcoal will dirty your hands.

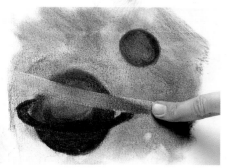

Charcoal disintegrates easily; the slightest touch is enough to ruin a drawing.

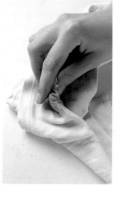

You can use the same rag to clean your hands that you use to erase. Cleanliness is essential, especially when you are handling the paper or working in white areas.

# The Direction of the Stroke

The direction of the stroke is fundamental for giving strength and truthfulness to an image. There are virtually thousands of kinds of strokes, and the lines they produce can go in any direction. To get good results, one has to know which strokes are best for each case, and in which direction they should be drawn.

## The Importance of the Stroke

The line is the foundation of any drawing, and it is important to know in which direction it should be drawn. The line can suggest everything you want to transmit in the drawing—the volume, texture, or weight of an object, the depth of a landscape, and so on. A curved line is ideal for suggesting spherical objects; straight lines are better for depicting flat surfaces; certain other types of lines come in handy for shading.

The drawing of this simple roof is composed of lines applied in all directions: One nearly horizontal stroke indicates the wall of the house; others drawn diagonally suggest the slant of the roof; the curves depict the slates; and the hatched lines are used for shadows.

## Drawing with Lines

To start to understand the expressive possibilities of the line, the beginner should practice drawing objects with only lines and strokes, putting blending techniques aside for the present.

The use of the line was fundamental in suggesting the rugged texture of this tree and the sinuous shape of the trunk.

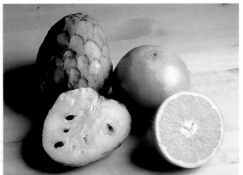

This still life subject exercise requires you to use only lines to execute the drawing.

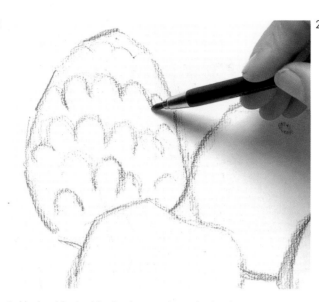

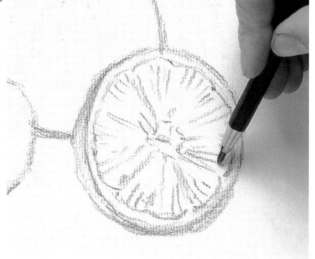

1. Having blocked in the forms, the artist begins to draw the skin of the custard apple, a tropical fruit, with semicircular strokes.

2. The texture of the orange is portrayed by drawing this series of lines from the center to the exterior skin. See how many of these radiating lines are drawn broken to make them more realistic.

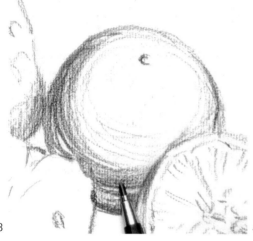

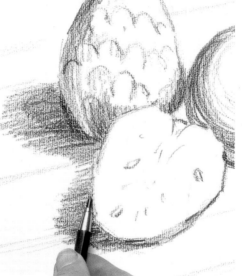

4. The shadows cast on the table can be drawn with these horizontal lines that give a sense of weight.

3. The artist brings out the orange's spherical volume by using circular lines. The custard apple's shadow is drawn with curved lines in a vertical direction.

5. Now that the drawing is finished, you can see how the combination of line directions gives excellent results.

**REMEMBER...**

■ The line indicates direction, volume, weight, and texture, so the right shading drawn with the wrong lines might produce a mediocre result.

■ The line must always follow the direction suggested by the model.

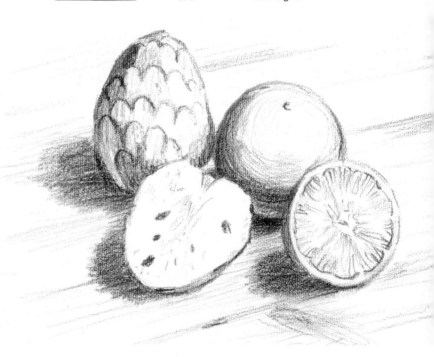

5

# *Blending*

Blending is an effective drawing technique. It is used to soften lines and make shaded areas that heighten the work, suggest textures, and create special effects, especially in the shadows.

## Blending Graphite and Charcoal

Both graphite and charcoal are blended using the same implements, although the result is different with each because graphite is slightly greasy and adheres well to paper, whereas charcoal is easily smeared and can produce sponged effects.

## Media for Blending

There are various types of implements for blending, with the results in each case slightly different. With the finger, for instance, one can create compact blended areas, because the natural grease of the skin binds the color. With cotton balls, the result is less consistent because it is not possible to exert much pressure on the paper. A rag is good for blending large surfaces that don't require precision. Cotton swabs are used for working on smaller areas and blending edges. Finally, the blending stick, which is designed only for blending, is versatile enough to produce dense stains, or sponged effects, according to the amount of pressure

This still life of candies is drawn in two versions: one in graphite and the other in charcoal. In both exercises the artist uses the same implements for blending; the results are somewhat different.

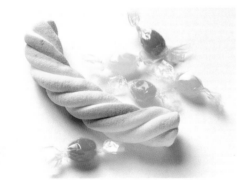

1. A rag is used to make the first gray areas, because it can produce light and varied shades, especially in drawings executed in charcoal.

2. Now, the artist blends the lines using a finger to create a more compact stain, because the natural grease of the skin binds the graphite pigment.

1

2

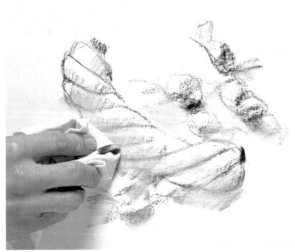

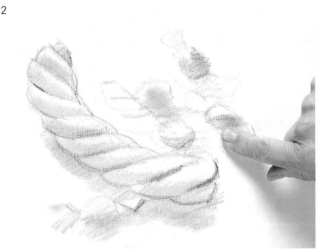

applied on the paper. The blending stick also
has a pointed tip created especially for blend-
ing tiny areas and detail.

3

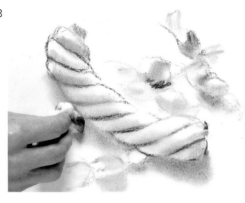

3. Cotton balls
produce the
opposite effect from
fingers, creating less
compact areas.

4. Due to their size,
cotton swabs are
extremely useful for
blending tiny areas
or borders.

4

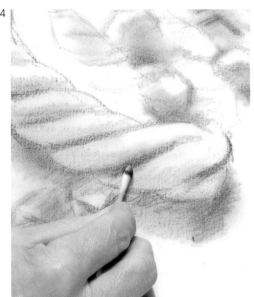

5

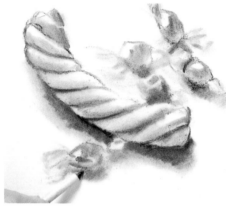

5. The tip of the
blending stick is
essential for working
in hard-to-reach areas
and for final details.

6. Thanks to its versatility, the blending stick
can be used to create any kind of shading.
In step 5 of the final stage of the exercise
carried out in graphite, you can appreciate the
differences. The drawing done in charcoal is
blacker and looks sponged; the picture
drawn in graphite shows the traces of the
strokes in many shadows while the shaded
areas are more compact.

6

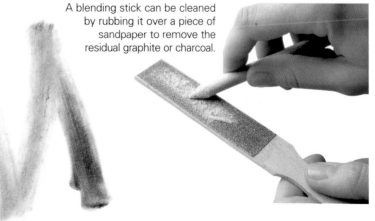

# Cleaning the
# Blending Stick

With use, the blending stick becomes so
full of graphite or charcoal that it can
be used for drawing. The problem is that it
can dirty areas that the artist wishes to keep
clean. To prevent this, it should be cleaned
by rubbing it over a piece of sandpaper.

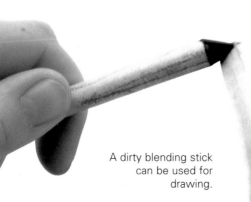

A dirty blending stick
can be used for
drawing.

A blending stick can be cleaned
by rubbing it over a piece of
sandpaper to remove the
residual graphite or charcoal.

# *Erasing with an Eraser*

The eraser is an indispensable tool for drawing: not only is it used for correcting errors, but also for recovering the color of the paper and creating highlights.

You only need to rub gently over the graphite line to erase with a soft eraser.

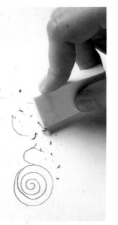

One way of getting a pointed rubber eraser is to cut off a piece with a utility knife.

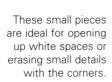

These small pieces are ideal for opening up white spaces or erasing small details with the corners.

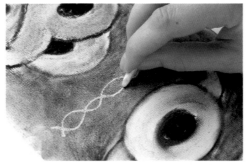

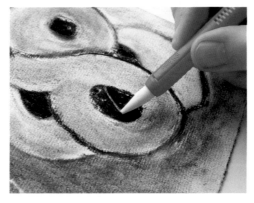

This eraser is equally good to use on detail, because the rubber can be sharpened to a point like a pencil.

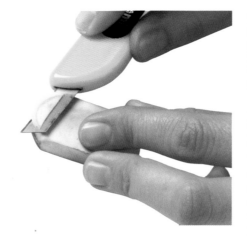

## Erasing Graphite

To erase graphite, a greasy material, you can use either a rubber or plastic eraser. Both are soft and are manufactured especially for erasing pencil marks without damaging the surface of the paper. Erasers should not be used too much, because overuse will damage the sheet of paper. In such cases, the best solution is just to use a new sheet. Like most erasers, soft erasers leave particles of rubber that must be removed by brushing with your hand or by blowing on the paper.

The eraser, besides correcting errors, can also be used as another drawing tool. By erasing specific areas of a drawing, you can suggest highlights or open up spaces of light.

## Erasing Charcoal

Charcoal is dry, unstable, crumbles easily, and, once applied to paper, acquires the consistency of dust.

A line or shaded area created in charcoal can be erased either with a kneaded eraser or with a soft rubber eraser. If there is a large accumulation of charcoal dust, it is better to work with a kneaded eraser, which will damage the paper less.

The kneaded eraser does not crumble like

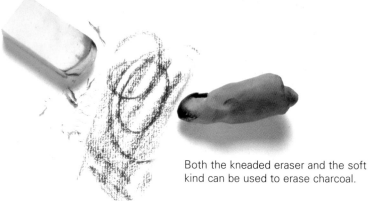

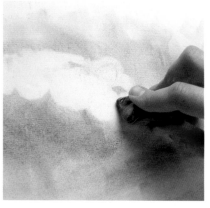 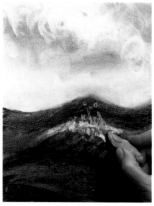

Both the kneaded eraser and the soft kind can be used to erase charcoal.

the soft eraser because it is made of a type of putty that absorbs charcoal. When a part of the eraser is saturated with charcoal and can no longer erase, all you have to do is knead it a little and erase with the other part.

The kneaded eraser absorbs charcoal dust from the surface of the paper, leaving it white.

A cloth is ideal for erasing large areas and is the quickest way to erase charcoal, although traces of the erasure will remain.

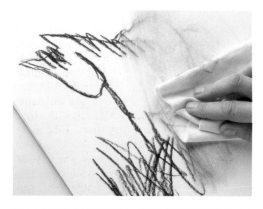 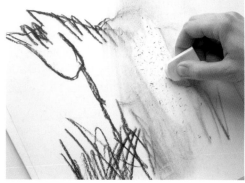

One of the advantages of the kneaded eraser is that it can be molded into points to open up small white areas or to erase inaccessible spots.

If you want to leave the paper clean after erasing with a rag, it is necessary to use a soft eraser afterward.

Some erasers can also be cleaned using soap and water.

# Cleaning the Eraser

It is essential to erase with a clean rag or clean eraser in order to avoid dirtying the paper. Shake the rag out occasionally while you work to remove the charcoal dust, and wash it regularly.

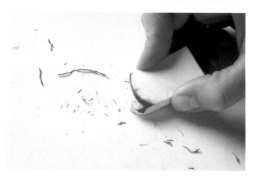

All you have to do to clean a kneaded eraser is mold it lightly, pulling the cleaner inner parts to the exterior.

A soft eraser can be cleaned by rubbing it softly against paper as if you were erasing. With use, the outer body of the eraser becomes dark from graphite and charcoal: if one end is kept clean for erasing, this should not be a problem.

# Composition

Composition is the step before drawing, because it is fundamental to the character and quality of your work. You can create many kinds of compositions using a single group of objects.

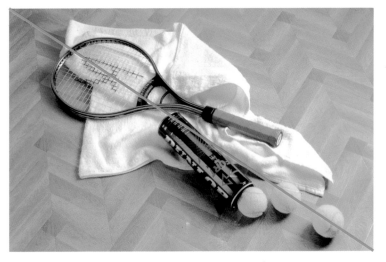

Some tennis equipment has been arranged into different compositions. In this, a diagonal composition, the position of the racket and towel help to suggest the imaginary line that crosses the paper. The can of balls adds weight to the lower half.

## The Diagonal Composition

The elements in the example of a diagonal composition can be reduced to a diagonal line that crosses the paper. In this kind of composition, you can use the diagonal to divide the image into two parts or use the cluster as a whole to indicate a direction.

## The Centered Composition

In a centered composition, the subject is placed in the center foreground of the picture to give a sense of unity. In the majority of compositions of this type, the elements that make up the subject can be reduced to a circle in the center of the paper.

In this composition, the elements have been arranged loosely in a circle.

There is a wide variety of compositions. In this one, the objects have been situated to suggest lines leading off in the four directions of an X.

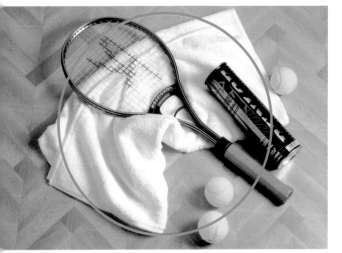

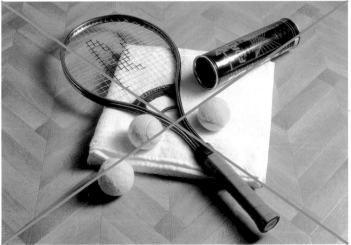

# The Triangular Composition

This composition involves arranging the objects in the shape of a triangle, and contains something of the centered composition, because the triangle is located in the center of the paper. The difference is that it doesn't allow the elements that compose it to form a closed circle.

REMEMBER...

■ The balance and harmony between the different elements of a still life depend fundamentally on a suitable composition.

■ The same objects arranged in different ways can evoke a variety of feelings.

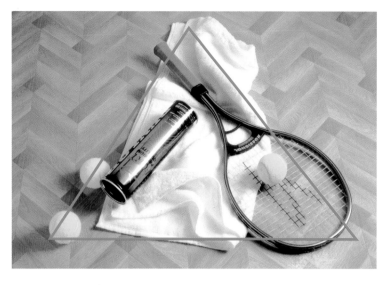

2. Having drawn the lines that define the composition, the artist begins to block in the elements.

2

1. This picture is drawn using a triangular composition. To begin, the artist sketches in the basic lines of the triangle; they are used as a guide for situating the elements correctly on the paper.

1

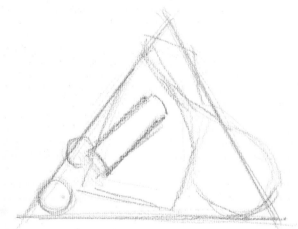

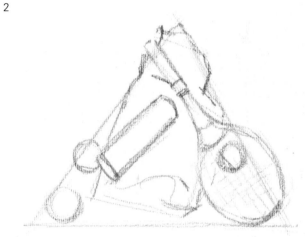

3

# Simplifying for Drawing

The best way to study the subject you want to draw is to reduce the composition to its simplest lines, then locate a balance within the frame of the paper. The artist should know how to do this, because it will help in transfering the forms of the subject onto paper.

3. Finally, the lines of the composition are erased, and shadows are added.

# *Framing*

Framing refers to how an artist situates the elements of the composition on paper to create the best possible balance.

A cardboard frame is used to select the best format for the picture.

## Framing

Framing is a fundamental part of the preparation of transforming your subject into a harmonious and balanced composition on paper. By framing, the artist chooses how to situate the subject or image within the specific space of the paper, including whether the composition will be vertical or horizontal, and what the exact borders of the image will be in the final drawing.

## Making a Frame

If you are not an experienced artist, you may find that the framing technique is more complicated than it first seems. One way of learning this technique is to use a simple cardboard frame to simulate the borders of the paper. By

1. Cut out two L-shaped pieces of cardboard using a right triangle and a utility knife.

2. Attach the pieces in such a way that the frame can be widened or narrowed; in other words, so it can be adapted to the needs of the moment.

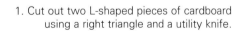

1

2

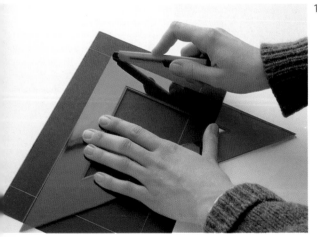

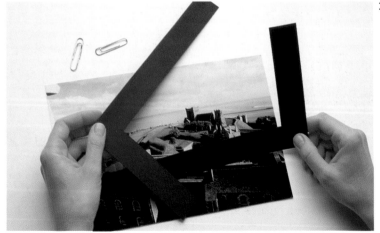

REMEMBER

■ The balance of the objects and the basic composition of the picture depend on good framing.

moving it around, you can decide which part you are going to draw.

This framing technique is similar to the way one frames a subject in the viewfinder of a camera before taking a photograph. Because you as an artist will probably only want to draw part of the image, you can adapt the frame to include those elements you are interested in.

# Framing an Image

It is impractical and uncomfortable to hold a frame while drawing, especially if you have not mastered the technique yet. So, many beginners prefer to take a photograph of the subject, and then draw it in the comfort of the studio.

1. This photograph demonstrates the technique of looking for the best frame to draw the distant building.

2. A frame, made out of two separate pieces of paper, can be adapted to any size or form that you want. In this case, viewing the image through an elongated frame doesn't make it appear very interesting.

3. Vertical framing is another possibility that produces completely different results, but the effect of seeing the roofs of the houses in the foreground makes the selected building look distant and less significant.

4. In this elongated option, an almost square format, the building is perfectly centered and commands greater interest. After choosing the format in which to execute the drawing, the two parts of the frame are fixed with paper clips to prevent them from moving, and you can begin drawing.

Here is the drawing done in the chosen format.

# *P*roportions

Respecting and transferring to paper the relationships and proportions of your subjects is fundamental to achieving a coherent and lifelike drawing as well as a good likeness of the original.

1. To begin this drawing of a teddy bear with a ball, divide the space into two basic parts: one that the bear occupies, and the other for the ball.

1

2. By using a pencil as reference to study the sizes and proportions of the subject, the artist can get an accurate idea of the difference in size.

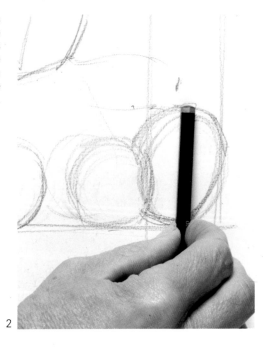

2

## Observing

O bservation is one of the keys to a successful drawing. Through it, the artist can become aware of the forms and proportions of the subjects and their relationship to each other. The professional draftsman can do this by merely glancing at the subject; the amateur has to carry out a more in-depth study.

Whichever the case, the artist should carry out a close study of the model before beginning to draw. It is better to spend a few minutes contemplating the objects and their sizes than to start spontaneously on a drawing that will inevitably have to be erased and begun over.

## Measuring Sizes

O ne way to transfer the measurements of the subject to the paper is by using your pencil as a reference. This method leaves little room for error, but you should recheck the measurements while you are drawing, because you may need to alter certain proportions.

**REMEMBER...**

■ To avoid making mistakes while measuring with a pencil, always hold the pencil at the same distance between your hand and body. The best way to do this is by holding the pencil at arm's length.

3
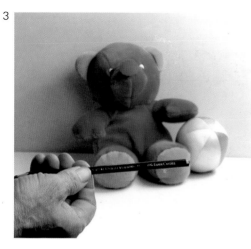

3. Having sketched the forms, the artist once again checks the proportions, in this case the width of the feet.

4
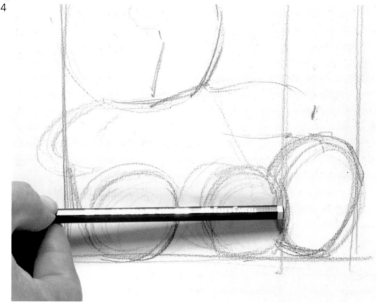

5
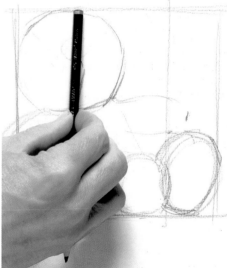

4. Even though the artist has taken measurements before drawing the first lines, he or she must check that the proportions, of the feet in this case, have not shifted in the development of the drawing.

5. Repeat the process with the size of the head.

6

6. Once all the proportions are checked, the artist can begin drawing with greater detail and a more confident stroke.

7
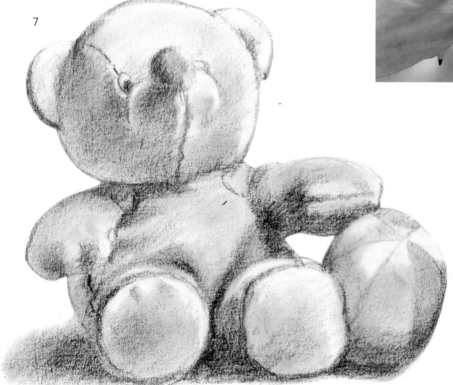

7. Next, the lines indicating the different areas are erased, and the artist can finish the drawing without having to worry about problems with proportion.

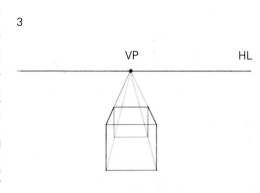

# *Perspective*

Perspective is a man-made system for representing the third dimension. Understanding the basics of this method and how it is used is a valuable aid for drawing.

1. Having drawn the horizon line, the artist sketches one face of the cube, and above it, in the exact center, indicates the vanishing point (VP).

2. Next the artist draws a line from each of its corners to the vanishing point.

3. Making a rough calculation of the distance, the artist draws the parallel lines of the sides of the cube, giving us the representation of a transparent cube in perspective.

**1**

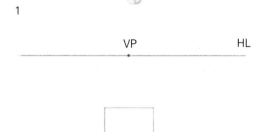

VP          HL

**2**

**3**

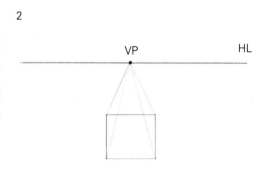

This cube may seem simple or useless, but there are literally thousands of objects that can be blocked within a cube or sketched as a cube. This is a good way of imagining those objects in perspective, as if we were looking at them from in front. One example of this is the armchair drawn on the right.

## What Is It Used For?

Perspective is a system devised for drawing three-dimensional objects on a two-dimensional surface, the paper.

It is essential for the artist to understand the basics of perspective, because they can give realism and coherence to the subject being drawn.

There is no need to have an in-depth knowledge of this subject; a few basic notions are more than enough to correctly represent objects in space.

## Parallel or One-Point Perspective

In this type of perspective, there is only one vanishing point. This is useful for drawing objects seen from directly in front. To the left is a graphic example of the use of parallel perspective by using the simplest three-dimensional form: a glass cube.

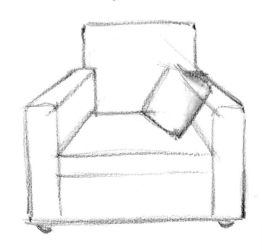

# Oblique Perspective

**O**blique perspective has two vanishing points and is used to draw an object seen from one side. This type of perspective is important. Because individuals do not usually see all objects in a picture from a completely frontal view, most of these objects have to be drawn in oblique perspective.

**REMEMBER...**

■ The horizon line (HL) is located at the height of the observer's eyes.

■ The vanishing points (VP) are the points to which the lines of the objects are directed.

■ It is likely that one or both vanishing points are located outside the paper. This should not present any problem, because all you have to do in those situations is direct the lines toward the place where they would be situated if they were on the drawing board or the table. (See: Drawing with Lines, pages 58–59.)

1

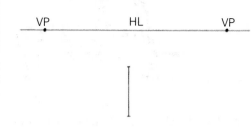

1. First, the artist draws the horizon line (HL) and a vertical line to represent the corner closest to us, as well as the two equidistant vanishing points of this corner.

2

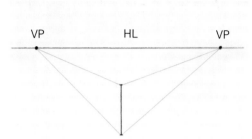

2. Next, the artist draws two lines from each point of the corner, one toward each vanishing point.

3

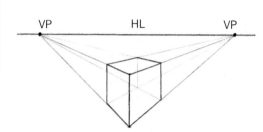

3. Once again, the artist makes a rough calculation of the size of the two lateral faces. These lines provide you with the points from which you can draw the lines of the top of the cube.

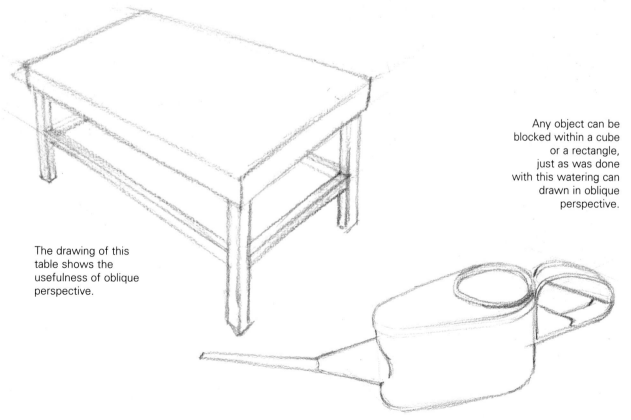

The drawing of this table shows the usefulness of oblique perspective.

Any object can be blocked within a cube or a rectangle, just as was done with this watering can drawn in oblique perspective.

# The Human Body

The human body, or figure, is one of the most common subjects of drawings, so, despite its relative difficulty, it is important to understand and know how to draw it.

Small children have bigger heads than adults do and their muscles are less developed.

The woman's body has breasts, wide hips, and a narrow waist. Also, the female body is curvier than the male.

■ Although there are certain rules for drawing the human figure, the division of the model into "heads" must be carried out with respect to the model's height, because some people are taller than others and universal measurements cannot be applied to everyone.

## Anatomy

The human figure is one of the most popular subjects in drawing, for both its aesthetic significance and its usefulness in studying movement and structure before beginning a painting.

The human body is composed of three basic elements: the head, the trunk, and the limbs. The anatomy of men and women is similar, though there are certain differences. Compared to men, women have thinner waists, wider hips, breasts, and narrower shoulders; in general, the shape of a woman has more curves. Men, on the other hand, have less indentation at the waist, flat chests, and narrow hips. Children are mainly differentiated from adults by the size of the head, which is large in proportion to the body, as well as having a rounded stomach and undeveloped muscles.

## Figure Drawing

As with any other object, the human figure can be reduced to geometric forms. Progressing beyond this basic sketch is difficult, given the complexity of human anatomy. One of the problems of drawing a figure is to represent properly the proportions of each part. To do this, one can use the old artist trick of dividing the body down its entire length into head-size segments, and using them to construct the parts.

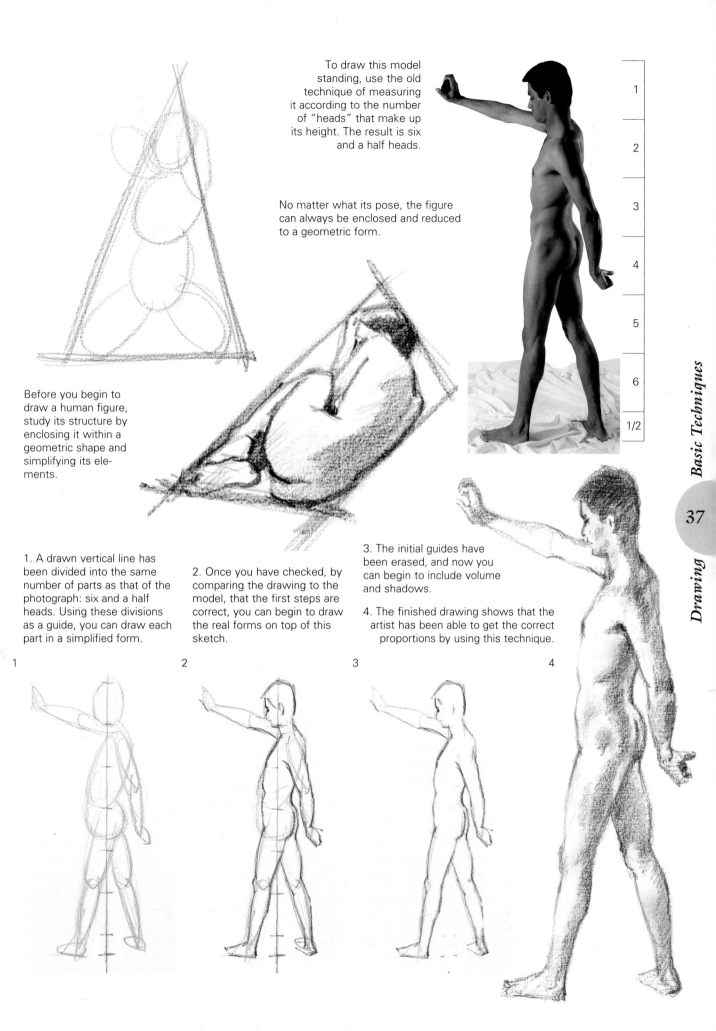

To draw this model standing, use the old technique of measuring it according to the number of "heads" that make up its height. The result is six and a half heads.

No matter what its pose, the figure can always be enclosed and reduced to a geometric form.

Before you begin to draw a human figure, study its structure by enclosing it within a geometric shape and simplifying its elements.

1. A drawn vertical line has been divided into the same number of parts as that of the photograph: six and a half heads. Using these divisions as a guide, you can draw each part in a simplified form.

2. Once you have checked, by comparing the drawing to the model, that the first steps are correct, you can begin to draw the real forms on top of this sketch.

3. The initial guides have been erased, and now you can begin to include volume and shadows.

4. The finished drawing shows that the artist has been able to get the correct proportions by using this technique.

1

2

3

4

# Transferring an Image onto Paper

Drawing is simply transferring a real or imagined image onto paper. The first steps are always difficult.

## Various Techniques

There are many techniques at the artist's disposal for transferring an image onto paper. Some are easier than others, and most involve a certain amount of "cheating." Even so, many artists use these methods to set down the first lines of their forms, so that they can then freely interpret the shading and details.

These techniques are especially useful for beginners, because they provide the chance to learn techniques without too much risk, especially when the subject they wish to paint is difficult. Later, you will want to master a more fluid drawing technique.

## The Grid

One of the techniques that is very laborious and involves actual drawing uses a grid. In this method, the artist divides the space of the paper into squares that serve as guides.

1. In this method, the artist overlays a printed image or a photograph with a grid.

2. The artist then draws another identical grid over this paper, but in proportion to the size of the sheet. Once this has been completed, the artist can begin to draw using the spaces as a guide.

**REMEMBER...**

■ When drawing the grid onto your paper, it is important not to press down too much with the pencil; otherwise, when you attempt to erase it, there may still be noticeable pencil marks.

A monochrome drawing is a real challenge because the artist must interpret colors as different shades of the same tone. To make this task easier, it is useful to work from a good quality black and white photograph of the subject, which will show you the range of grays that make up the image.

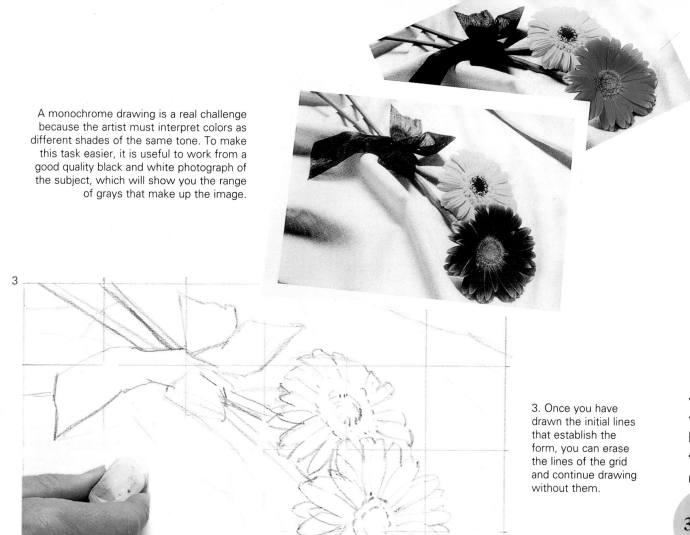

3

3. Once you have drawn the initial lines that establish the form, you can erase the lines of the grid and continue drawing without them.

4

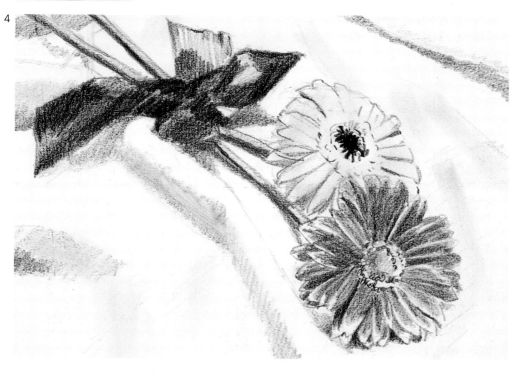

4. In the finished drawing you can see that there are no traces of the grid lines, because they were drawn softly and could be erased fully.

# Tracing an Image

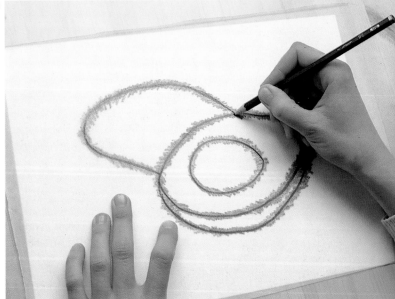

Tracing also involves using a printed image or photograph as a guide. Tracing is probably familiar to most people from their school days. The drawback of this technique is that normal drawing paper is not transparent enough to trace over. Instead, you have to use tracing paper to make the outline of the image you want to draw, and then transfer it onto drawing paper.

40

The following demonstrates how to trace an image from a photograph of a subject that is simple but interesting.

1. The artist places a sheet of tracing paper over an enlarged version of the photograph and begins to trace the avocado.

2. Then, using a soft pencil, the artist draws a thick band of graphite along the entire length of the outlines. This gives the artist a kind of improvised carbon paper.

3. Once this has been completed, the artist can turn the paper over and situate it on the drawing paper. Then, the outlines are gone over with a pencil.

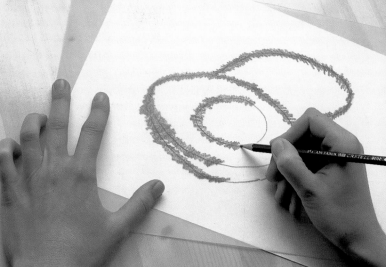

4
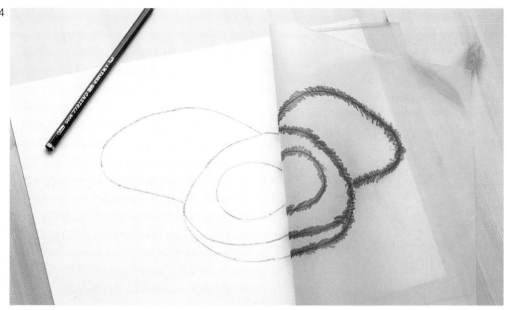

4. The image has been cleanly transferred to the drawing paper.

5

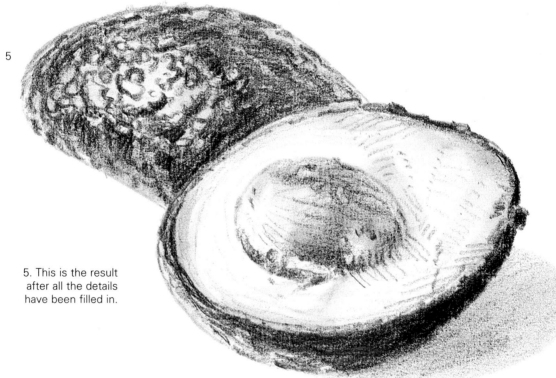

5. This is the result after all the details have been filled in.

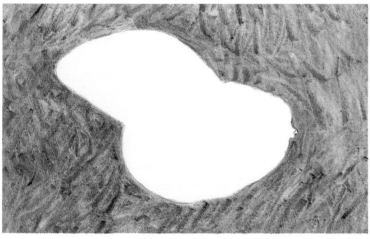

Although the tracing technique does not allow the artist to analyze the object within its surroundings, it is good for understanding its forms and volumes. One good exercise is to draw the subject in negative, such as was done here. The true contours of the fruit are the result.

# Projecting the Image

T he amateur photographer can use slides as subjects for drawing. Like other examples discussed here, this involves copying the main outlines and then filling in the drawing to give it a more natural and personal character.

This technique is good in drawing large pictures. You will use a slide projector to project the images onto the drawing paper so that the contours can be outlined in pencil or charcoal.

The artist can take advantage of the framing of the slide to decide which part of it will be used as the subject. The projector also allows you to copy only one image and then draw it in a different context.

You will have to move the projector around to find the right distance and angle to project the image onto the drawing board and paper.

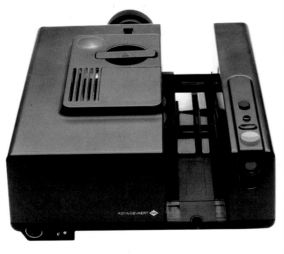

Slides shouldn't dictate your drawing. An artist can work from a projected image and frame it according to personal preference. You can also use this technique to draw sketches as if you were working from nature.

**REMEMBER...**

■ Don't try to get down every line when you trace because your work will look artificial and impersonal.

■ Only use the slide projector for transferring the main outlines to the paper. The rest of the drawing should be done in freehand by the artist.

# Process

To draw from a slide, project the image onto the paper, adapting the scope of projection.

Once the image has been sharply focused, begin to draw the outlines of the subject, avoiding creating shadows with your hand. During this stage, the artist may choose to include shadows, although it is recommended that you do this without the aid of the projector, because you will want to give your own character to your wrok.

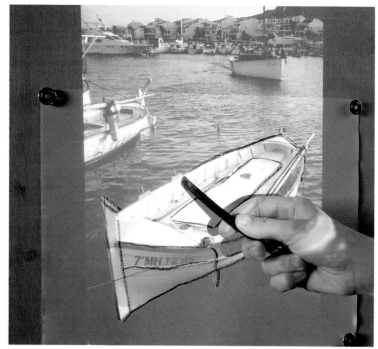

1. First, project your subject onto a sheet of paper that is attached to a drawing board. Next, outline the shape of the boat in charcoal.

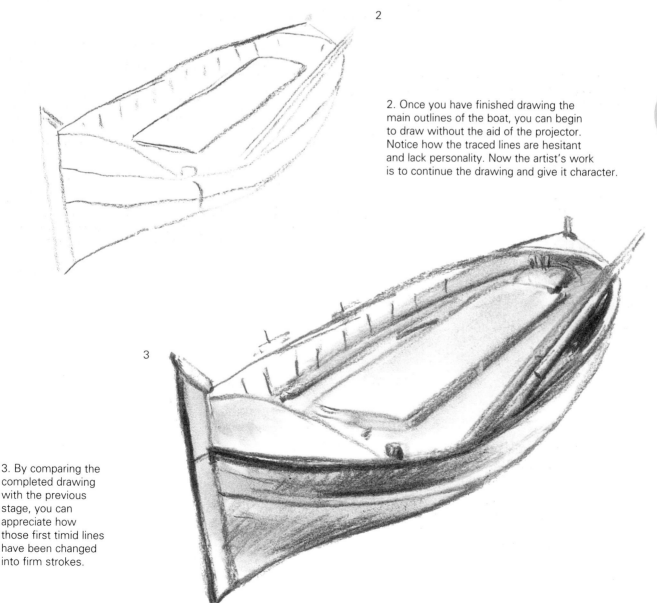

2. Once you have finished drawing the main outlines of the boat, you can begin to draw without the aid of the projector. Notice how the traced lines are hesitant and lack personality. Now the artist's work is to continue the drawing and give it character.

3. By comparing the completed drawing with the previous stage, you can appreciate how those first timid lines have been changed into firm strokes.

# Drawing Sketches

Sketching the form, shadows, and composition of a subject is the best way to study it in depth. This exercise forces the artist to make close and detailed observations before beginning to draw.

## The Importance of the Sketch

A successful drawing requires the artist to closely observe the subject before beginning to draw. This is the only way to get a likeness of the original model. Draw as many sketches as you need before starting on the definitive drawing. It is important to study all the aspects of the subject in depth, from its correct framing to the contrasts of shadows, the complexity of the shapes, their synthesis, and the structure of the entire image.

The artist uses the sketch to observe shapes and shadows, pulling the image together with quick strokes.

There are many types of sketches: in this one, for example, the artist concentrates on the form rather than the shadows.

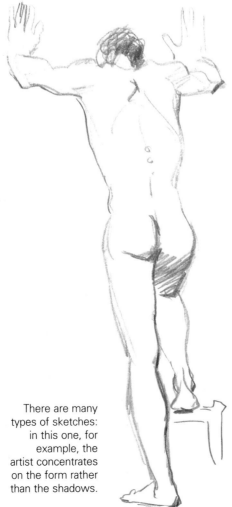

A sketch of this nature, with detailed forms and shadows, will be a good guide for a later drawing, because it is no longer necessary to have the model in front of you.

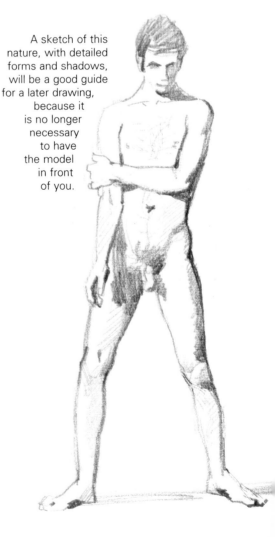

# How to Sketch

Sketching is similar to drawing. The main difference is that a sketch is a more spontaneous form of drawing. In the sketch, an artist tries to pull together forms and shadows, working rapidly with strong strokes, and avoiding detail. The results of this type of work are often more energetic than the definitive drawing.

It is best to sketch on inexpensive paper, such as the recycled kind, or on pads specially designed for this purpose. The artist should not try to include details, only to summarize the form and shadows in a few lines and shadings.

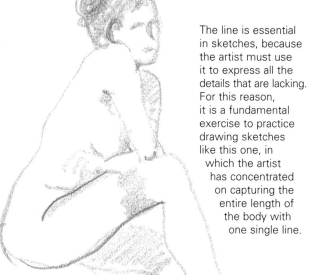

The line is essential in sketches, because the artist must use it to express all the details that are lacking. For this reason, it is a fundamental exercise to practice drawing sketches like this one, in which the artist has concentrated on capturing the entire length of the body with one single line.

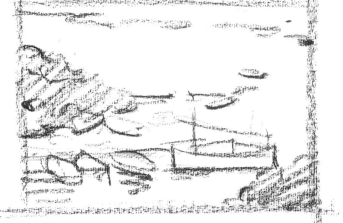

Another purpose of the sketch is to choose the framing. In this case, the artist has opted for a rectangular one.

Here is the same landscape framed within a vertical format, the result of which is very different.

A sketch is useful for studying forms from nature and thus acquiring reference material that can be worked with later in the studio.

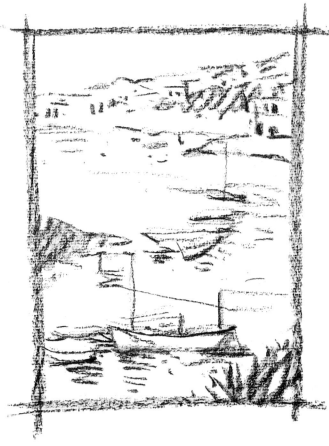

# Tones, Light, and Shadows

The interplay of light and shadow on an object produces a whole spectrum of tones that range from the lightest to the darkest. This variety of tone is the means by which artists show volume in their works.

This example of tones was drawn using an HB graphite pencil.

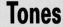

## Tones

Tones are the different degrees of intensity a color can display while remaining the original color. The tonal gradation of a color ranges from the lightest to the darkest tones a color can produce. In the case of charcoal or graphite drawings, tonal ranges comprise the scale of grays from pale to black.

To get very light tones of gray using charcoal, the white of the paper must be allowed to remain visible; when you press harder with your charcoal, the texture of the paper is covered and you get a coal black.

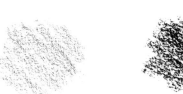
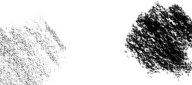

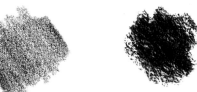
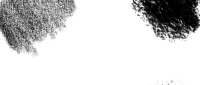
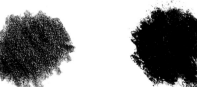

## Building Up Tones

Both graphite and charcoal produce a wide range of tones depending on how forcefully they are applied to the paper.

To get the lightest tones, barely touch the paper with your charcoal or graphite. If you increase the pressure, the tone becomes darker. This does not necessarily mean pressing down hard on the paper, because the artist can also go over the same area again and again until the tone deepens naturally. This is the technique preferred by most, as there is no risk of spoiling the surface of the paper.

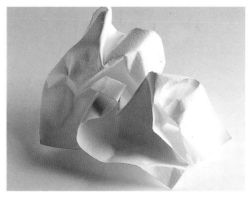

Drawing a crumpled piece of paper is a good exercise for learning how to draw various surfaces by using tones.

# Light and Shade: The Interplay of Tones

When tonal scales are being made, it is not necessary to leave white space to see the differences between them.

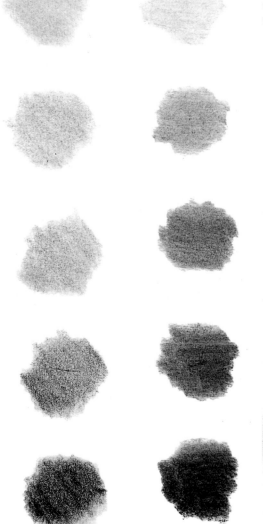

The interplay of light and shadows creates a sense of volume. The artist interprets this interplay of different intensities of light as a range of tones.

An illuminated object always has an area of greatest light and another of greatest darkness. These areas of greatest darkness, or shadow, can be those cast by the object on the ground or surrounding objects, or those that it casts on itself.

**Shadow cast:** (A) The shadow cast on another object.

**The object's own shadow:** (B) The shadow cast by an object on itself.

**Point of greatest darkness:** (C) Depending on the type of lighting, this darkest point may be the object's own shadow or, as in this case, a shadow it casts on itself.

**Light point:** (D) This is the point where the natural color of the model does not vary; that is, it appears neither light nor dark.

**Highlights:** (E) The points of greatest luminosity that appear to be virtually white.

A     B     C    D   E

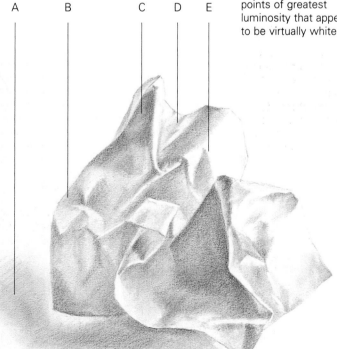

*Basic Techniques*

47

*Drawing*

Natural charcoal        HB soft graphite        8B graphite

# Degrees of Hardness

Each brand's natural charcoal usually has a consistant hardness. Compressed charcoal both in stick and pencil form, and graphite in general, is usually sold in varying degrees of hardness. The hardest graphite is used for drawing details and lines in gray tones. The softer kinds draw black lines and are the most suitable for artistic drawing.

The different effects that you get from drawing with pencils of different hardnesses can be used by the artist in his work, particularly in playing with tones. You may even want to switch between a graphite and charcoal. (See Charcoal and Graphite, pages 6–7.)

# Creating Highlights

Highlights are the most intense points of light of an object. The artist usually gets them by using the white of the paper itself, either leaving it untouched while working or by erasing marks afterward. Another way to create whites is by using chalk, in sticks or pencils, to add touches of white.

# The Light Source

The light source is a basic factor in creating feelings and giving the subject special characteristics. Frontal lighting produces very few shadows on objects, giving them a very "clean" appearance. If the light source is close to the ground, the same object can look strange or eerie.

With this slightly raised frontal lighting, the shadow of the cactus is hidden behind it. The plant can be seen plainly, in complete detail.

White chalk is good for adding touches of light on colored paper, or on areas of a drawing where it is not convenient to use an eraser.

Even though the artist has not drawn on the fold of the crumpled piece of paper, a pointed eraser is used to get a cleaner white.

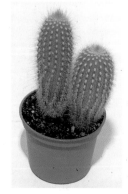

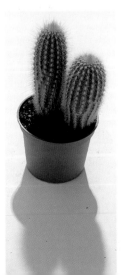

Putting the light source behind the subject is called backlighting and makes the dark shadow, or silhouette, of the object or person stand out.

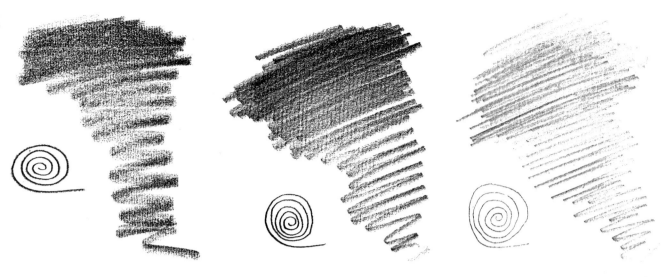

6B graphite                    HB graphite                    3H graphite

■ Lighting gives the subject feeling.

■ Shadows follow the direction of the light.

# The Direction of Shadows

The shadows on an object and the shadows it casts both follow the direction of the light. You can figure out the way different shadows are cast by drawing straight lines that originate from the light source. Remember that these lines radiate out from the center of the light in all directions, so they can never be parallel.

1. The subject here is the cactus, lit from the side. After drawing its outline, the artist draws a line indicating the direction of the light.

2. These lines show the right direction for "casting" the shadows. All you need to do now is draw them, starting at the base of the pot.

3. Once the problem of the length and direction of the shadows has been dealt with, the "guidelines" are erased and the drawing is completed.

Lighting is the basic factor that creates the feeling of an image.

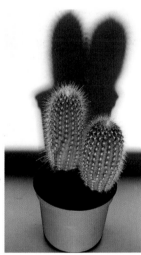

Shadows are cast in the direction of the light.

Lateral lighting is the ideal type for beginners to use because it creates shadows on the object itself that clearly define its volume. At the same time, it also casts shadows on the ground or nearby objects.

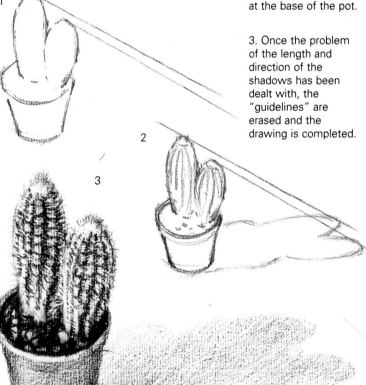

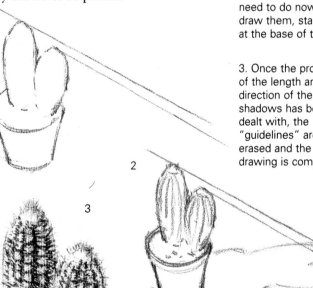

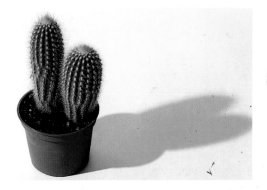

# How to Draw with Graphite

When you draw in graphite, you begin by choosing the subject and studying it carefully. The process ends with the final touches that give the drawing a sense of volume.

The subject chosen for this exercise is the elegant figure of a giraffe, with its stylized and attractive outline and playful patterns crisscrossing its skin.

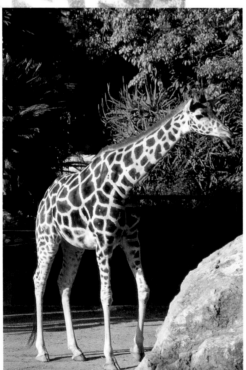

## Blocking In and Studying the Subject

Before you start on the actual drawing of your subject, you should make a few sketches to study its structure and acquaint yourself with its form. This makes your later work easier. Each artist has his or her own method of working, although there are common techniques that make drawing easier. For instance, most artists begin by outlining the volumes and simplifying the forms. This will help you grasp the basic structure of your subject and coordinate its constituent elements, in this case the head, trunk, and extremities.

A soft 6H pencil will be used for this drawing, along with a soft eraser and an ordinary blending stick.

Before beginning the actual drawing, the artist made this small sketch of the giraffe's body to study its basic structure.

# Defining Forms

Once you have sketched the outline of the body, examine it to make sure that the forms and proportions are correct. If they aren't, you will have to erase it and start again. If it's all right, you can begin to define the figures in more detail.

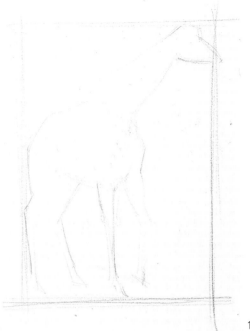

1. The figure of the giraffe can be blocked in as a rectangular shape. You should draw it first as a geometrical figure to make sure that the proportions of the body and its posture are correct later.

1

3

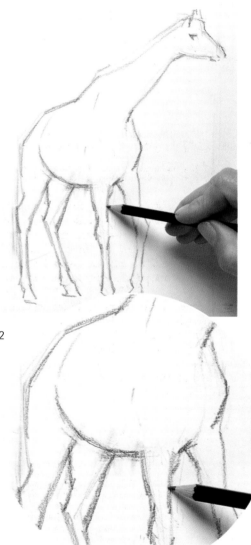

2

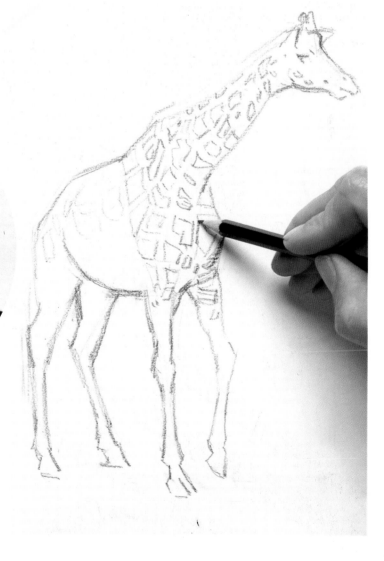

2. After this first light sketch (which should be easy to erase later if there are mistakes), try to see if the outline is accurate. If it is, you can proceed confidently to add definition.

3. Continue by sketching in the pattern of spots on the giraffe's skin, then adding the various tones.

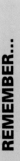

# Creating Volume

Apart from the main outlines that suggest which parts are nearer or farther, a sense of volume is created by the interplay of light and shadow. Once the forms have been defined, the artist can begin to introduce those elements that finish the drawing, including retouching and adding final, small details.

4. The spots on the animal's skin are drawn by copying directly from the subject. This heightens the realistic effect.

5

## REMEMBER...

■ Lighter shadows can be made by rubbing gently with a slightly dirty blending stick or by stretching out or smearing the pigment of graphite lines or patches nearby.

■ An accurate and detailed drawing requires time.

■ In addition to light and shadow, the outline of the figure also contributes to a sense of depth in the drawing.

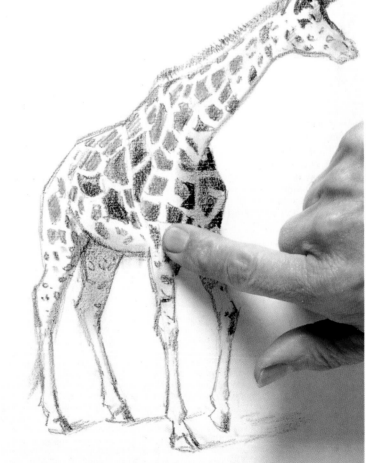

5. The spots on the skin are blended slightly with a finger to soften the contours and suggest the soft texture of the coat. The soft shadows on the chest and rear leg are done the same way.

7. Erase small areas between the spots to restore the pure white of the paper and bring out light areas.

8

6. The tip of a dirty blending stick is useful for darkening the nose and blending the dark patches and lines on the head. The same technique has been used to draw the shadows on the ground. You can see how important this shadow is if you compare this sketch with earlier ones without it, in which the giraffe seems to be floating in midair.

8. The finished work shows how much time the artist took to execute such a thoroughly meticulous drawing. Even the tiniest details have been drawn, such as the texture of the giraffe's mane and the messy hairs of its tail.

53

# *Drawing with Charcoal*

The process for a charcoal drawing begins by choosing a particular composition and frame and ends with the application of fixative over the completed work. In between, the artist works on forms and shading.

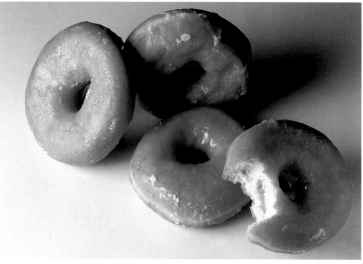

## Blocking In Forms

The first step consists of studying the composition after choosing the format. Then the basic lines are sketched in to situate the forms on the paper. It is important to make sure that the proportions are right and that they are drawn in the right perspective.

Paper, a stick of charcoal, a blending stick, and a kneaded eraser are the only materials necessary to draw a picture in charcoal.

When drawing a still life made up of a group of identical objects, it is important to make sure that they are arranged in an interesting composition. The artist paints this still life of doughnuts to show how the simplest of forms can create interesting images.

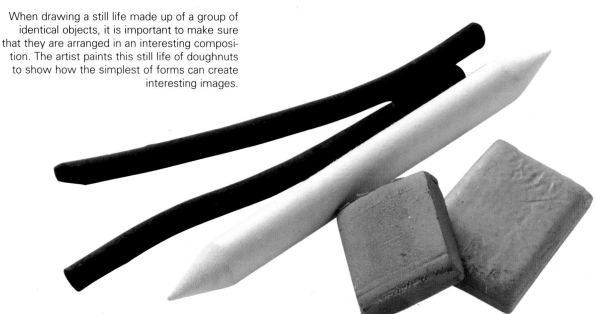

■ Before you start to shade in areas, it is important to study the preliminary forms to make sure they are placed right and that the proportions and perspective are correct.

■ The results you get from blending with a finger are slightly different than from blending with a blending stick.

1

1. The composition of the doughnuts can be blocked in a rectangle. Within these four lines, you can draw their outlines and distribute them accurately.

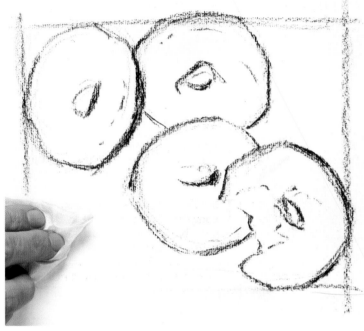

2

2. The next step is to erase the composition guidelines with a rag.

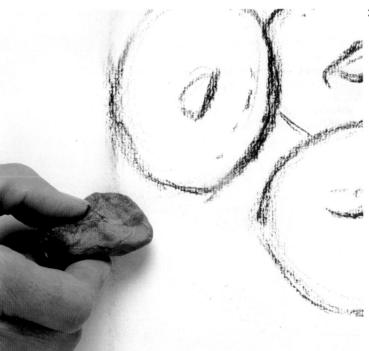

3

3. Because some traces of charcoal always remain, go over the area with a kneaded eraser.

4

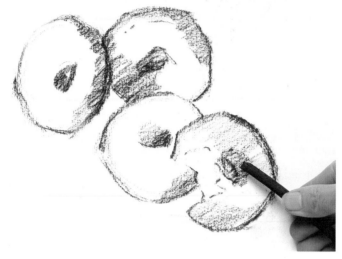

4. Begin to shade by softly rubbing the stick of charcoal over the surface of the paper.

# Shading and Blending

Once the forms have been properly arranged on the paper, you can begin to shade them in. You must be careful not to put the shadows in too soon. The artist should stop and make sure the drawing is right. Don't forget that it is a lot easier and cleaner to erase a line than to erase a dark shaded area.

# Retouching and Adding Details

The last stage of a drawing, as important as the earlier ones, consists of drawing details and retouching the shadows, highlights, and contours. This phase is the time to give depth and contrast to the picture, as well as definitively to establish the textures.

5

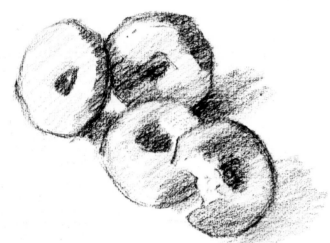

5. The areas in shadow have now been shaded in, with more pressure applied to the darkest areas. It is important at this point to avoid stark contrasts because if you darken a shadow too much it is not easy to lighten it.

6. Now, begin to blend the shaded areas with a finger. This can be carried out equally well with a blending stick, although it is important to bear in mind that blending with a blending stick results in denser shadows.

6

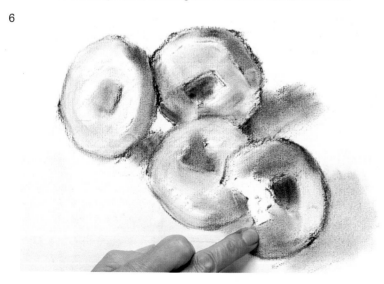

7

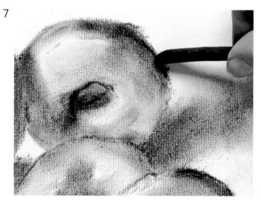

7. Stop now for a few minutes to compare the drawing to the subject. It is immediately clear that certain areas need to be intensified. All the artist needs to do in this case is apply a touch more charcoal and then blend it again.

**REMEMBER...**

■ The blending stick can also be used to create special effects.

■ To open up a white area with an eraser (soft or kneaded), you have to use a clean part, because any other part will dirty the paper.

■ To get pure whites, after using the kneaded eraser, go over the area with a plastic one.

8

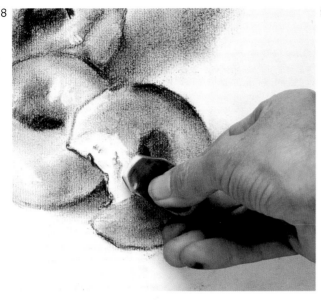

9

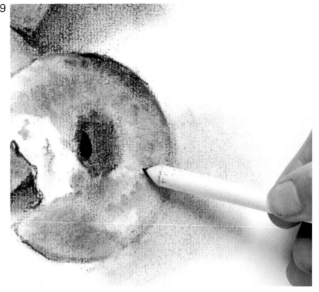

10

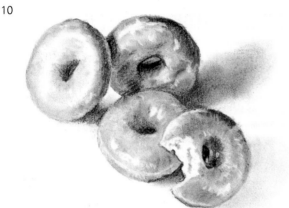

9. Use a few more touches of the eraser to suggest the sugar covering the surface of the doughnuts, and then blend certain parts with the blending stick to show the rough texture of the dough.

10. Once the drawing is finished, apply some fixative to it to prevent the charcoal dust from rubbing off and ruining your work.

8. Open up white areas with either a rubber or plastic eraser to bring out the highlights. It is important to keep in mind that even though most of the eraser may be covered in charcoal dust, you have to make sure that the part applied to the paper is clean, or you will smudge the paper.

11

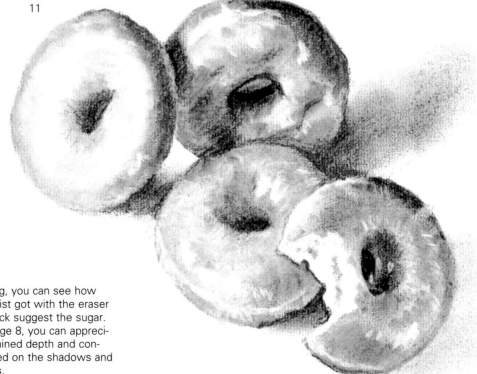

11. In the finished drawing, you can see how the special effects the artist got with the eraser and tip of the blending stick suggest the sugar. If you compare it with stage 8, you can appreciate how the image has gained depth and contrast after the artist worked on the shadows and emphasized the highlights.

# *Drawing with Lines*

There is no need to use a blending stick when drawing with graphite, because the expressive capacity of its line is so great that you can make wonderful drawings without using any smudging techniques.

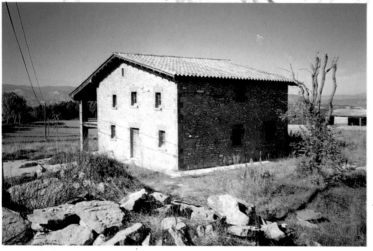

## Drawing a House

In this exercise the subject is drawn in perspective. To do this, it is necessary to sketch in a horizon line and establish the vanishing points. In this case, they lie outside the borders of the paper. Once you have done this, you can start work on the drawing. You will make it exclusively with lines, just as you would with a pen.

The subject chosen is a country house that lets you use two vanishing points.

1. Begin by drawing the horizon line and putting in the vanishing points. The fact that they are located outside the paper itself should not pose any problem, because the artist has extended the horizon line outside of the confines of the paper by drawing it on the drawing board. The line that is drawn from these two points provides you with the correct perspective with which to draw the house.

1

2

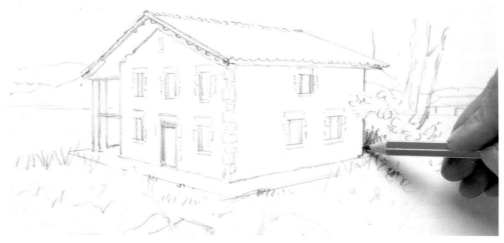

2. Once the body of the house has been drawn in perspective, you can erase all the lines that might interfere. Then, begin to block in the forms for the shape of the house and for its surroundings. Don't forget to go over by hand those lines that were drawn with a ruler. That will make them less rigid.

3

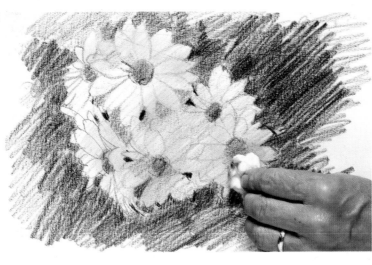

4. Begin drawing with the eraser, opening up whites in the brightest parts of the petals.

4

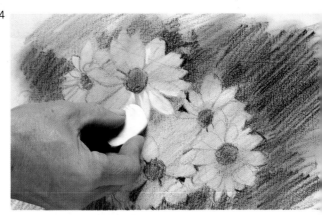

3. Now, you are going to "dirty" the paper with the aim of cleaning it later. The artist has lightly shaded the parts of the petals and, with the aid of some cotton, has spread the graphite over the entire area.

5

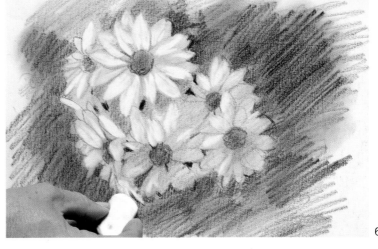

63

6

5. To keep the eraser clean, rub it occasionally over a separate piece of paper.

6. Continue erasing areas of the petals, taking advantage of the corners of the eraser to open up the most intricate highlights.

7

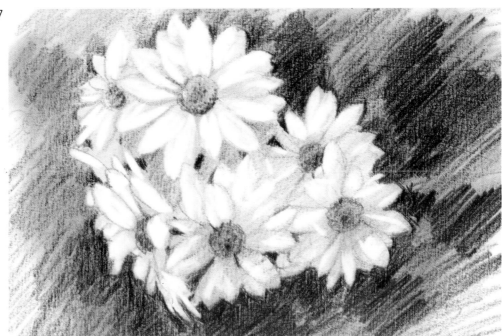

7. The drawing is finished. The artist darkens the background again, creating uneven shaded areas that suggest the leaves under the daisies. See how the buds of the flowers have also been retouched.